Picture Windows

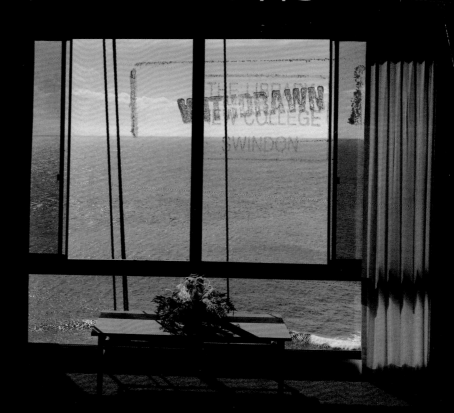

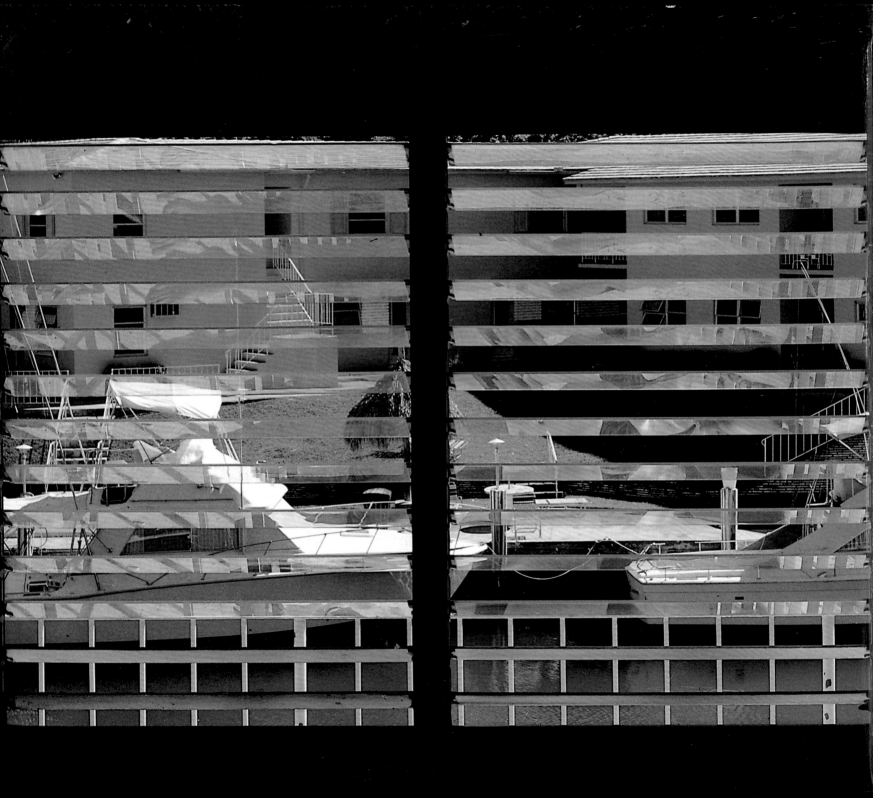

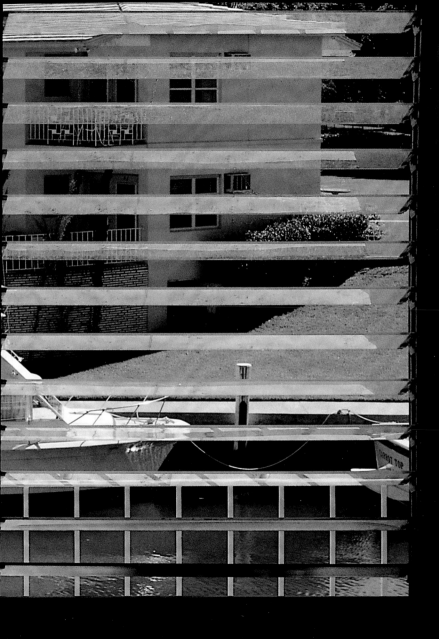

Picture
Windows

Photographs by
John Pfahl

Introduction by Edward Bryant

A New York Graphic Society Book Little, Brown and Company Boston

*To my mother, who introduced me, at an early age,
to photography and to the concept of a really clean window.*

First edition

Library of Congress Cataloging-in-Publication Data

Pfahl, John, 1939–
 Picture windows.

 "A New York Graphic Society Book."
 1. Photography—Landscapes. I. Title.
TR660.5.P49 1987 779'.36'0924 87-3273
ISBN 0-8212-1665-1

New York Graphic Society books are published by
Little, Brown and Company (Inc.).

Published simultaneously in Canada by
Little, Brown and Company (Canada) Limited.

PRINTED IN GREAT BRITAIN

Plate 1 (frontispiece): Maui, Hawaii
Plate 2 (title page): Coral Gables, Florida
Plate 3 (contents page): Rockport, Massachusetts

Contents

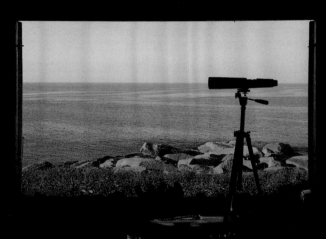

Introduction

SINCE THE 1950s the picture window has been commonplace in the American visual vernacular. Its ubiquity has coincided with that of the wide-screen movie, the undivided windshield, the big painting, and that ultimate picture window, the television set. Surely, deep cultural needs spawned these inventions that expanded the act of looking. The picture window was not for long primarily an embellishment of suburban tract houses but soon spread to service stations, restaurants, apartment complexes, hotels and motels, nature centers—almost any place that an ordinary window once occupied.

Regardless of what is outside a picture window, the pull of a drapery cord immediately shifts that portion of the exterior world into relationship with the interior, expanding the apparent space and framing the exterior view. The intermediate pane of glass delimits and detaches that segment of the outer environment, like the plane of a canvas separates art from reality. The implications of that framed window picture provoked John Pfahl into traveling through much of the United States to create some of his most innovative photographs.

Picture Windows (1978–1981) presents the three-dimensional phenomena of visual perception fixed within the two dimensions of the photographic print. In these works Pfahl demonstrates a creative vision that extends beyond the usual parameters of straight photography. Whether it involves the ordinary or the spectacular, his visual logic expands conventional habits of seeing to include a fresh regard for the enigmatic fabric of visibility itself.

Pfahl's work has continually involved a dynamic interplay between the two- and the three-dimensional. In his 1974 artist book *Piles,* cutouts pop up as piles of wood, hay, salt, sand, and snow. In *Altered Landscapes,* the 1974–1978 series for which he first became widely known, he fabricated devices within actual landscapes that the camera recorded as geometric shapes on the picture surface.

The creative strategy for *Picture Windows* evolved from Pfahl's response in the late 1970s to the abundance of large-format color work being done. For many photographers, the lush color and striking aggregate of details seemed to ensure that every shot would be beautiful, visually interesting, and seemingly foolproof. Pfahl too was attracted to these sensuous qualities, but he wanted to use them as an integral part of the conceptual basis for new work in a way that would require him to use his wits. He also wanted to reduce his output and avoid

Edward Bryant

the expense of too many pictures that were merely beautiful, in favor of more demanding ideas.

He decided to take pictures only through windows. This was not an arbitrary decision, for the window in art has had a full history. Since the Early Renaissance, when Alberti explained linear perspective as the transformation of the picture plane into an open window, it has been variously used for symbolic, emotional, and formal purposes.

Whether looking inward or outward, as viewer, voyeur, or eyewitness, photographers since the beginning of the medium have framed their view of the world using both window and camera. Their diversity is only hinted at in the examples of Eugène Atget, Robert Doisneau, Harry Callahan, Robert Frank, Nathan Lyons, Ralph Eugene Meatyard, and Garry Winogrand. Pfahl's uniqueness becomes most evident when his work is compared with that of Josef Sudek, who also surrounded his lighted windows with darkness. Although at first glance they seem closely related, Sudek is a poetic expressionist, Pfahl a poetic phenomenologist.

Pfahl's decision to photograph windows was also based on a practical reason. Living in Buffalo, New York, he had to figure out how, during the severe winters, to pursue his primary interest in landscape photography. Photographing landscapes through windows seemed the best solution. At first, his idea was to continue his *Altered Landscapes* series by setting up a system of markings on windows that would relate to elements in the exterior landscapes but would appear to have been placed on the photograph after it was printed. He rejected that idea because it would have taken so much more time to set up and clean up than even the outdoor fabrications had. It was too much to impose upon people who might agree to let him photograph their windows.

So, Pfahl began taking photographs of windows with nothing added. "Rochester, New York" (Plate 15), made in July 1978 at the Visual Studies Workshop, was one of the earliest. He soon realized that some of the things that happen to windows, such as the stains on this one or the chance arrangement of broken panes of glass (Plate 25), are natural forms of mark-making —a welcome shift from the fastidious setups for *Altered Landscapes*. By taking this new route, he felt removed from the scene, able to step back and see it in a fresh context.

"Torrey, Utah" (Plate 39) is an extension of this interest in making marks on windows. While cleaning the very large, dirty window in an abandoned building so he could photograph the spectacular scene outside, Pfahl decided to shoot through the spray of glass cleaner as it ran down the window, like rain in an utter desert. He whimsically calls this one "Homage to Windex." Another example of marks made by happenstance can be found in "Gimlet, Idaho" (Plate 38), which comes close to Marcel Duchamp's concept of the "ready-made aided" with its delightful paradox of a frozen exterior seen through frosted glass etched with a tropical lagoon of flamingos.

"Santa Monica, California" (Plate 12), made in March 1978 at an old motel where Pfahl stayed en route to Hawaii, was his first picture window photograph. It includes the more expansive structure and context characteristic of the series. The strict alignment of format with verticals, horizontals, and diagonals is a throwback to his *Altered Landscapes,* but the overall geometric pattern of the photograph belongs to the evolving new series.

Once Pfahl made the decision to photograph only windows, he had the problem of how to get inside the homes of strangers to photograph their views. When he had exhausted the possibilities of friends' and relatives' homes, he had to knock on strangers' doors. At first he left his card with a note stating his purpose and requesting a response. No one replied. His next strategy was more straightforward. Dressing in light-colored clothes to appear nonthreatening, turning up his unaffected appeal, and carrying (like a wedding photographer) an album of Polaroids of his picture windows, he set out to charm

his way in to the other side of a lot of windows. After taking the photographs, he enjoyed casual chats about art, aesthetics, and the concept of the window as a picture. These interviews turned out to be one of the more interesting aspects of the project.

Other windows came more easily. In Gainesville, Florida, Pfahl hired a real estate agent to take him to all the houses for sale in the area, a venture that provided the most windows he ever considered in a single day. This worked especially well, since, being prepared for purchase, none of the houses had curtains up. "New York, New York" (Plate 21) came about because Pfahl always selected a hotel for the potential of its windows. While walking down Eighth Avenue one day, he saw the scaffolding for a large billboard under construction, adjacent to a hotel. He checked in after the clerk let him examine the view from corresponding rooms on several floors to see which would be best for his purposes.

In these photographs nothing is accidental or unobserved. Pfahl meticulously sets up the shot through a picture window stripped to its basic rectangle in a darkened room. He considers all elements, especially weather, time, and season. He has mulled over some sites for months, even longer, and then returned to make the photograph. The images are fairly formal in purpose; their content is cool and detached. Pfahl says that his interest lies in the scene itself, without sociological comment. His decisiveness recalls how painstakingly Cézanne composed his landscapes, sighting, shifting, and changing viewpoint, until all pictorial elements came together to achieve the parallel but separate reality of his art.

Pfahl exposed all of the photographs using a 4 x 5″ view camera. The exact position of the camera in relation to the window was very important, for every window has not just a single view but many. Raising and lowering the tripod or moving it from side to side brought into play new elements and relationships, while others disappeared from the ground glass.

A selection of telephoto and wide-angle lenses provided additional possibilities, and trapezoidal distortion of the window's right angles could be avoided with the view camera.

Using Polaroid film, Pfahl made several preliminary images from different vantage points to see which would be best for his final color shot. He exposed the negative for the scene outside, allowing the room to fall into darkness. He usually removed all objects from view but sometimes retained them if they enhanced the total effect.

He set the focus so that everything from inside the windowsill to infinity would be resolved into a consistently sharp image, compressing all into a shallow "in-focus sandwich." Such a focal length differs radically from that of the human eye, which focuses variably on either what is on the windowsill or what is outside the window, but never on both at the same time. With everything in the picture focused, all forms interact regardless of their relative locations in space. This pushes every element up to the photograph's surface, making it a field for formal relationships that never exist in normal human vision. For example, in "Marblehead, Massachusetts" (Plate 4), the distant shore is as clear as the pieces of tape on the windowpanes in the foreground.

The surface of the photograph is given further emphasis by printing a black border around it. By doing so, Pfahl suggests an extension of the darkness of the room to the edges of the horizontal print. This brings the rectangle of the window into direct relationship with the rectangular format of the photograph. Moreover, the darkened room surrounds and so intensifies the color, thereby increasing the forward push of the in-focus sandwich and giving the room itself an equivocal function. Although we tend to read the black of the room as a positive form around the window and its backlighted dividers, we can easily shift our reading to that of rectangular shapes separated by interstices within a continuous black ground. Thus, "Vermillion Cliffs, Arizona" (Plate 40), can be read either

as a Southwest landscape through three screened windows or as a triptych of Navaho rug–like images superimposed on an unlit backdrop.

Conversely, in other photographs some landscape elements can be so assertive as to detach themselves from the distance and become singular images floating up to the plane of the window, as do the white, whale-like shape in "Anaconda, Montana" (Plate 45) and the snowdrifts in "Sun Valley, Idaho" (Plate 46). Hence, Pfahl reveals to our eyes and imagination some remarkable visual episodes.

One of the most popular photographs in the series was made in the snackbar of the Parrot Jungle near Miami (Plate 9). The three perches seem to hang equivocally either inside or outside the window—and to be the same image repeated three times, like successive images on a contact sheet. A similar spatial ambiguity exists in the image of a cozy garden room (Plate 11) in which the white birches outside appear to crowd forward into the room.

Setting up for one of the *Picture Windows* shots generally took two hours or more, but sometimes Pfahl had to work faster than that. He almost always removed curtains, so the rectangular form of the window could be maintained. To have photographed the windows with the flowing folds and arcs of their curtains and valances would have shifted the series in another direction. (A few times he did leave curtains up, but only when he felt they contributed to the structure and tone of the composition, as in Plates 1, 19, and 40.) Likewise he rejected circular, triangular, and other odd-shaped windows.

Jalousie windows and venetian blinds, on the other hand, were an integral part of the rectangle and could provide a controlled, yet dazzling complexity. In "Coral Gables, Florida" (Plate 2) the adjustable glass louvers act as semitransparent mirrors, intercutting reflections of Pfahl's wife sunbathing with a view of boats and buildings beyond. "Los Angeles, California" (Plate 13) is a three-part visual feast: the central panel, a precise interplay of glass louvers and roof tiles; the side panels, open windows through which we see, as clearly as in a Flemish painting, geometric passages of roof and landscape details. The horizontal blind slats in "Carmel Highlands, California" (Plate 48), taken in Ansel Adams' kitchen, appear to function like television scan lines to define the subject. In "Buffalo, New York" (Plate 18) the slat lines are analogous to the masonry courses of the church façade.

Travel has always been essential to Pfahl's photography. He constantly searches for scenes to transform into that viewable object, the photograph. A catalyst to discovering the previously unseen, travel brings us a sense of the moment, of change, and of moving on after the exhilaration of finding something unseen. Perhaps this is a cultural vestige of those restless pioneers who kept moving on, more for new visions than for the rich strike. Pfahl's images of the American West recapture something of the visual conquest of space and nature found in the survey photographs of William Henry Jackson and Timothy O'Sullivan. Yet, Pfahl's photographs of our country's natural beauties have an entirely different intent.

His concern in photographing the West is to represent those clichéd images that people carry around in their heads as keys to confronting the actual landscape. Part of our cultural baggage, these "mental postcards" can be traced back at least to the early Romantic ideas of the picturesque. From the eighteenth century into the first half of the nineteenth century, artists and sophisticated travelers in Europe and America used a "reducing glass," a small, darkened convex lens, to frame and isolate fragments of the landscape as "art," according to current concepts of the beautiful and the sublime. Today, throngs of tourists use their instant cameras for the same purpose. Sometimes tourist trails are marked with signs for the most photographic views or feature sheltered overviews with windows framing that "best shot." These serve as another kind of reduc-

ing glass, whereby nature can be appropriated and controlled via cliché.

Those picturesque concepts have been modified by the pictorial devices of the Hudson River School, Luminism, the epic landscapes of Albert Bierstadt and Thomas Moran, and the photographs of O'Sullivan and Jackson. In turn, their ideas have been modified by Hollywood Westerns and television. In *Nineteenth-century Video Landscapes,* his early series of black-and-white photographs, Pfahl showed how television uses the same techniques for filming landscapes in *Fantasy Island* as did Eadweard Muybridge in photographing Yosemite National Park. Pfahl's *Power Places* (1981–1984) demonstrated how outmoded Romantic attitudes toward nature determine our relationship to the environment.

"Garden of the Gods, Colorado Springs, Colorado" (Plate 44), was his first picture window of a place famous for its scenic beauty. Not until printing this image did Pfahl see, on the far left, a young woman taking a picture of her male companion. Pfahl's photograph of the Grand Teton from inside the Chapel of the Transfiguration (Plate 33) is identical to a postcard for sale there. All day long, tourists enter the chapel, walk to the middle of the room, aim their cameras, take the shot, and, without lingering, walk out. This was Pfahl's one opportunity to take the same picture everyone else had. However, as seen within the context of the series, it becomes a statement about the clichéd image.

Of course, he had to stop at Mount Rushmore (Plate 32) as so many other photographers have done, so he talked his way into the gift shop manager's office. This must have been the same building outside of which Lee Friedlander took his famous 1969 black-and-white photograph of two tourists looking at the monument, which is reflected in the glass behind them.

With his Western picture windows Pfahl comes as close as he ever does to making a pointed sociological statement.

"Grand Canyon National Park, Arizona" (Plate 43), like other Western photographs in the series, critiques what we have done to nature and the wilderness in the United States. We can scarcely find wilderness scenes without there being a building or structure within which to frame them. Often, our experience of wilderness areas in national parks is not natural, but mediated; we are taught how to look at nature, how to see a scene. Before starting out on the paths, we see orientation slides that will likely appear more attractive than their real counterparts. Viewing nature has become parallel to looking at animals at the zoo, both marginal efforts to relate once again more fully to the world. The couple sitting on a bench in Pfahl's picture make a telling symbol of this reality. Like the surrogate viewers of German Romantic painter Caspar David Friedrich, they sit, passively absorbing the grandeur of the Grand Canyon like a wide-screen movie.

Pfahl feels that the sunset image of "Springdale, Utah" (Plate 41) is the most personally significant photograph in *Picture Windows.* Although the first picture window he conceived, it was one of the last photographed. While on a three-week lecture tour in 1977, he was driving through vividly colored Zion National Park in southwestern Utah, when he saw in the distance a house with a picture window, overlooking a compelling view of red mountains. He did not stop, but the image remained with him, and three years later he returned to find the house. Apprehensive about the kind of reception the owners might give his idea, he was delighted when his visit seemed almost expected. There followed a race to take down the curtains, move the furniture, and set up the shot while the late afternoon sunlight was still on the mountains. (In his haste, he left the Polaroid test image within view on a table near the window; he decided, finally, to leave it in the print as a comment on the photographic process.)

The subtle, yet accessible complexities pervading *Picture Windows* are object lessons in seeing, made viewable through

5

the perceptions of an exceptional artist. Three factors conditioned these photographs, each analogous to the others in structure and function. The first—the eye and the brain (the Greeks called the eye "the window of the soul")—is a telescoping of the other two: the lens and the camera (Latin for "chamber" or "room"), and the windows and the darkened room (a *camera obscura*). John Pfahl says that taking these photographs was like being inside the brain looking out through the eye. Another thought constantly recurred while he looked into the ground glass in those darkened rooms: the camera seemed to be inside another camera. Then he envisioned countless other cameras sitting all over the natural landscape, waiting for him to come and enter them, to take the pictures they had been saving for him.

EDWARD BRYANT
Albuquerque, New Mexico
April 1987

Picture
Windows

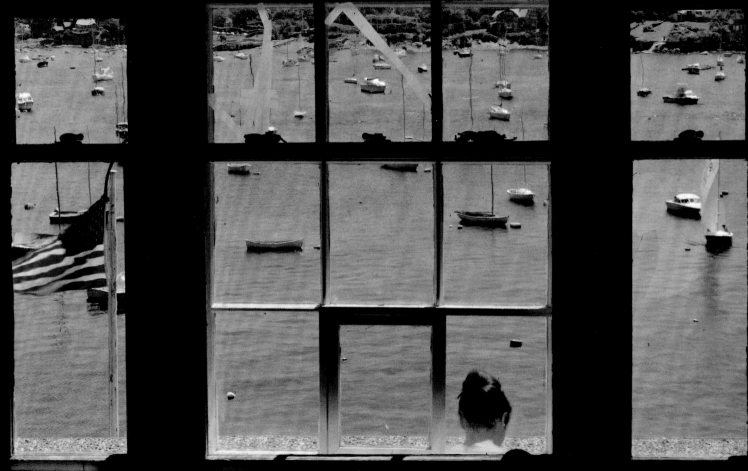

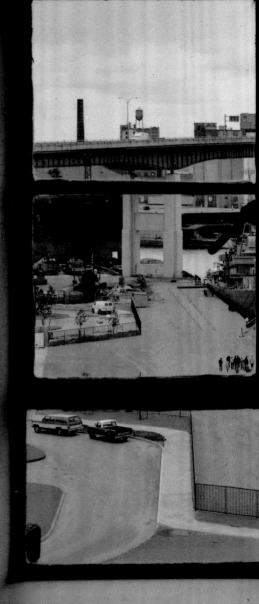

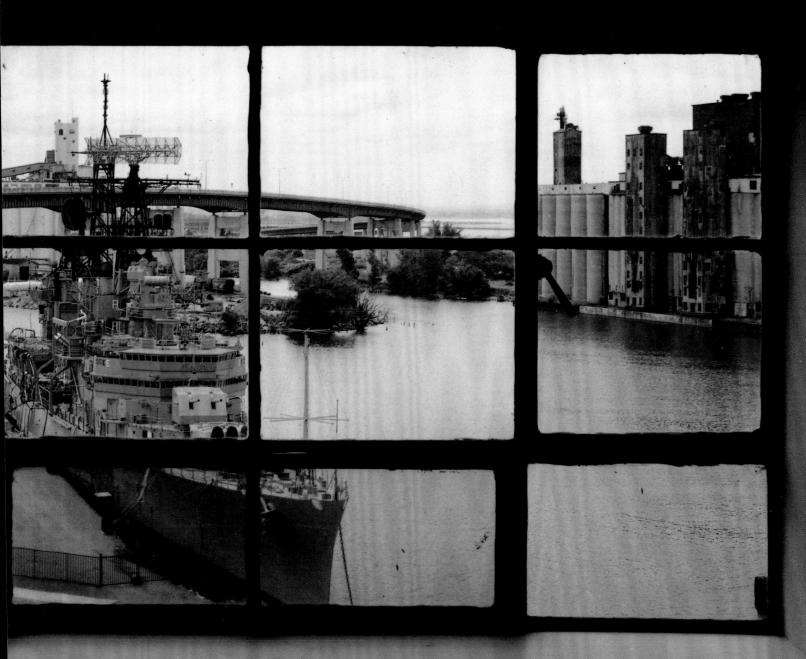

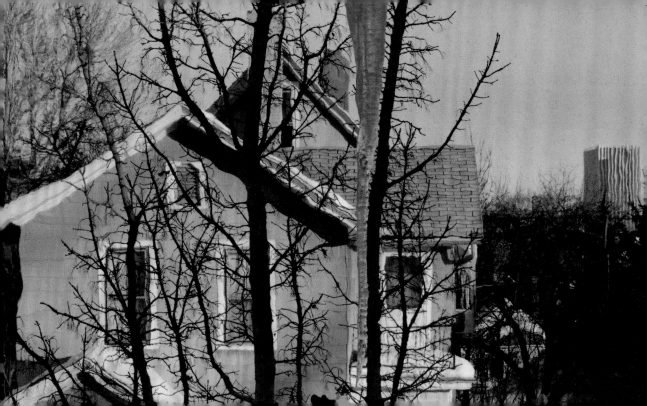

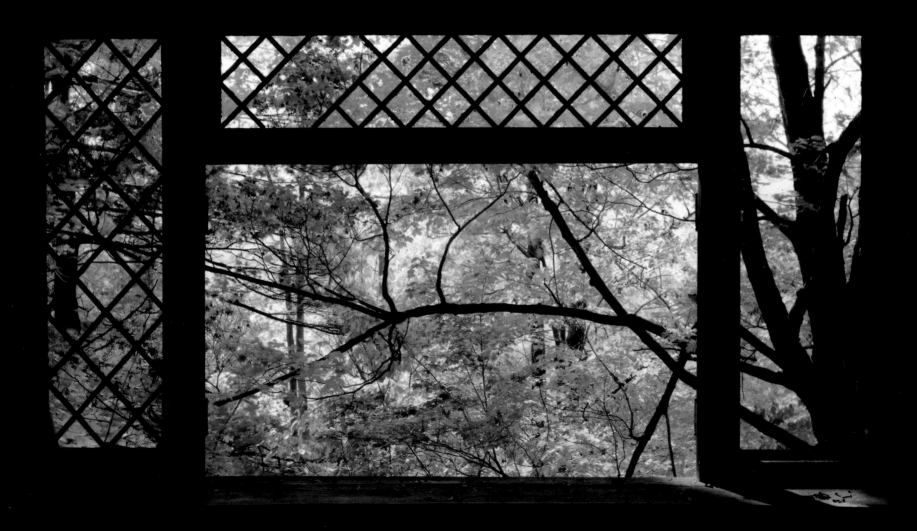

7 Dansville, New York

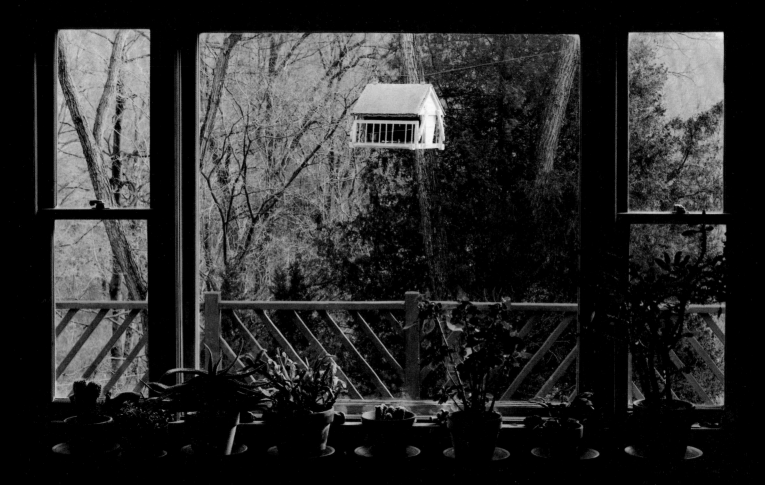

8 Ringwood, New Jersey

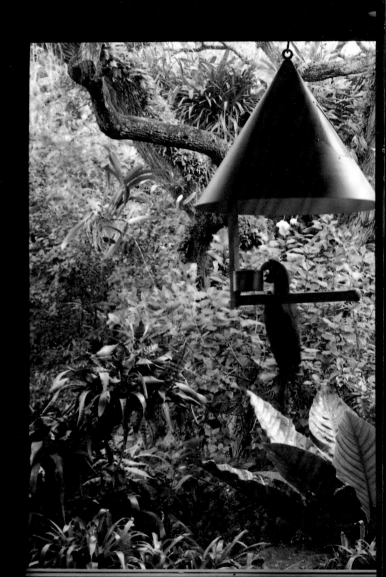

Miami, Florida

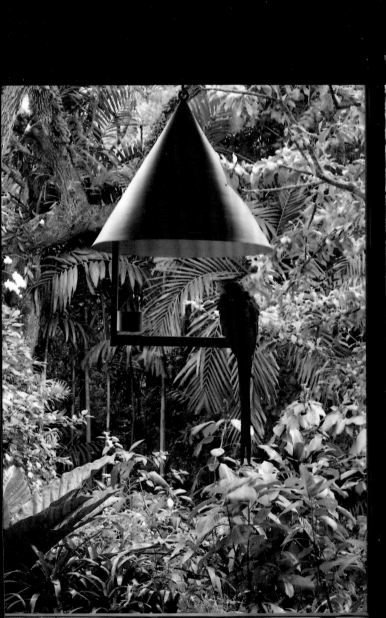
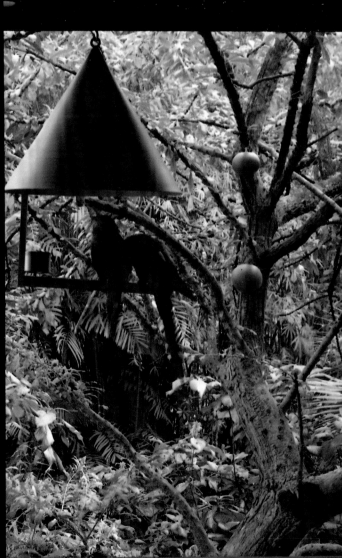

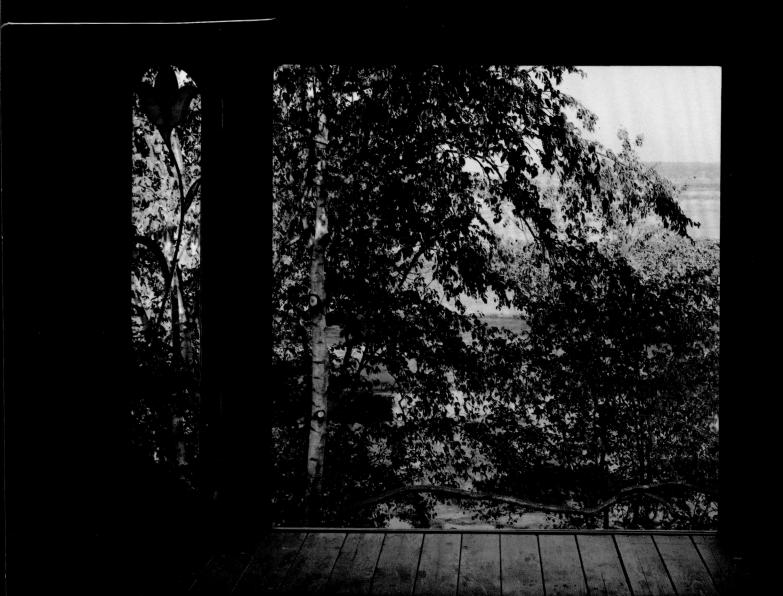

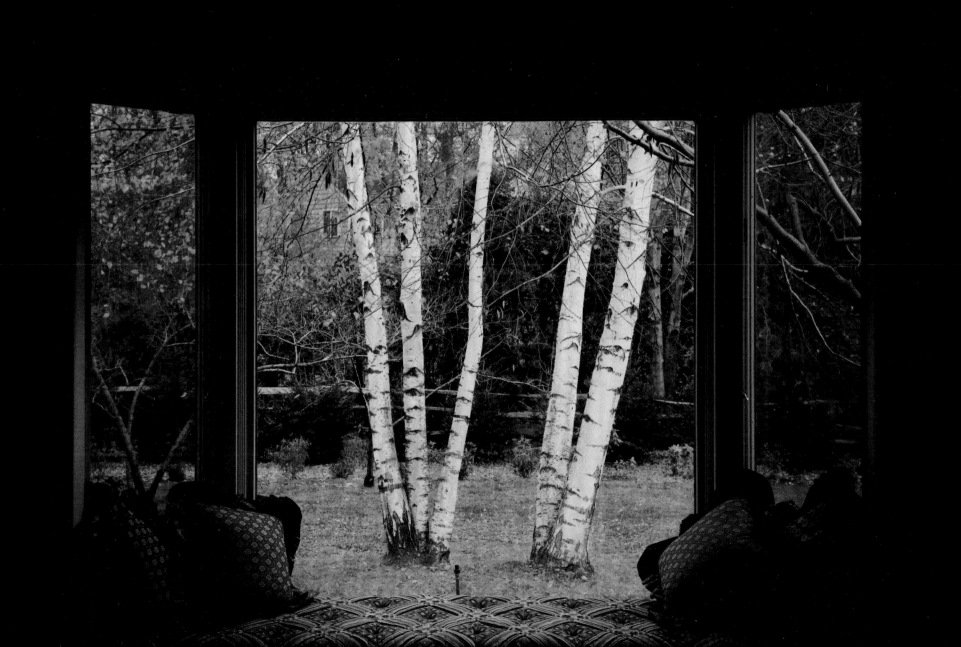

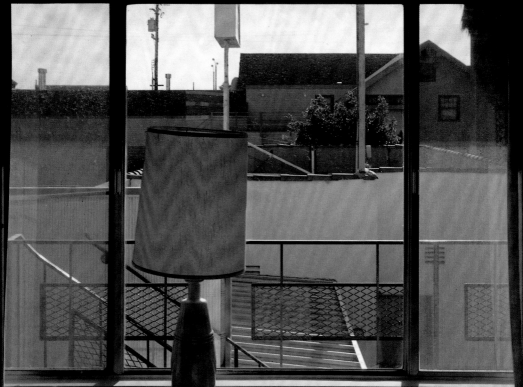

Los Angeles, California

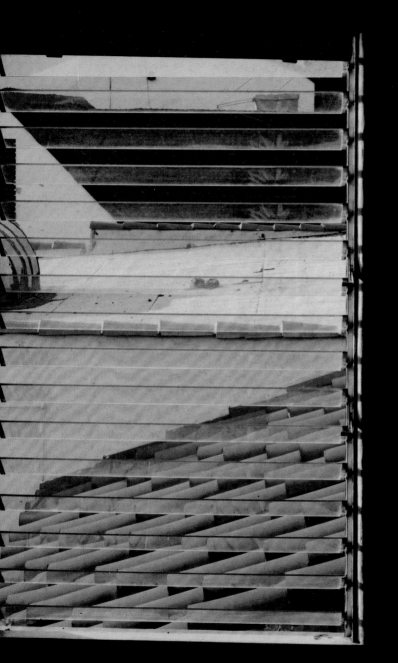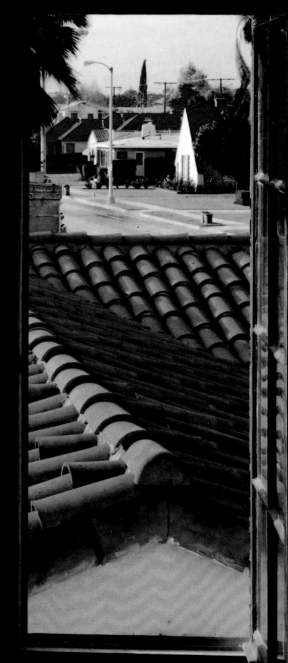

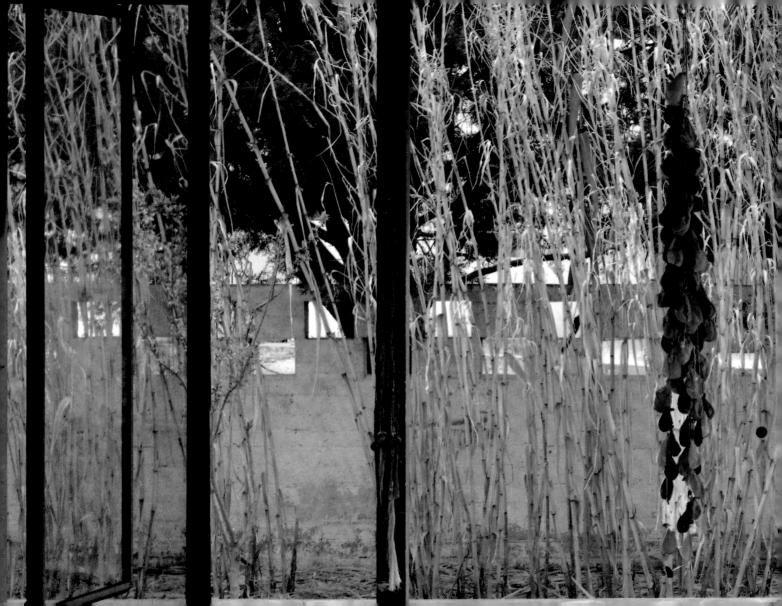

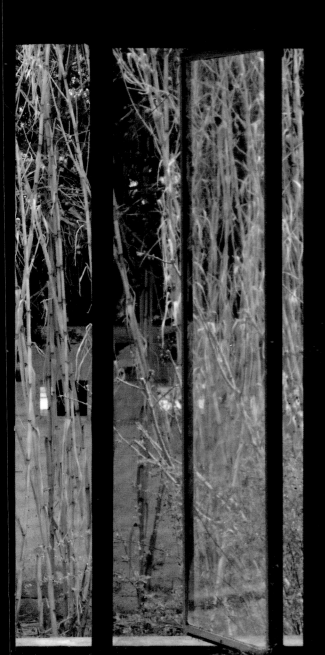

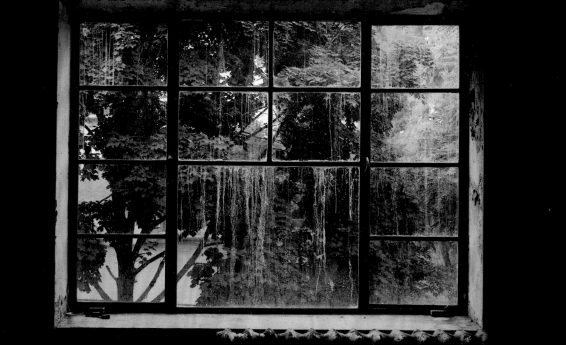

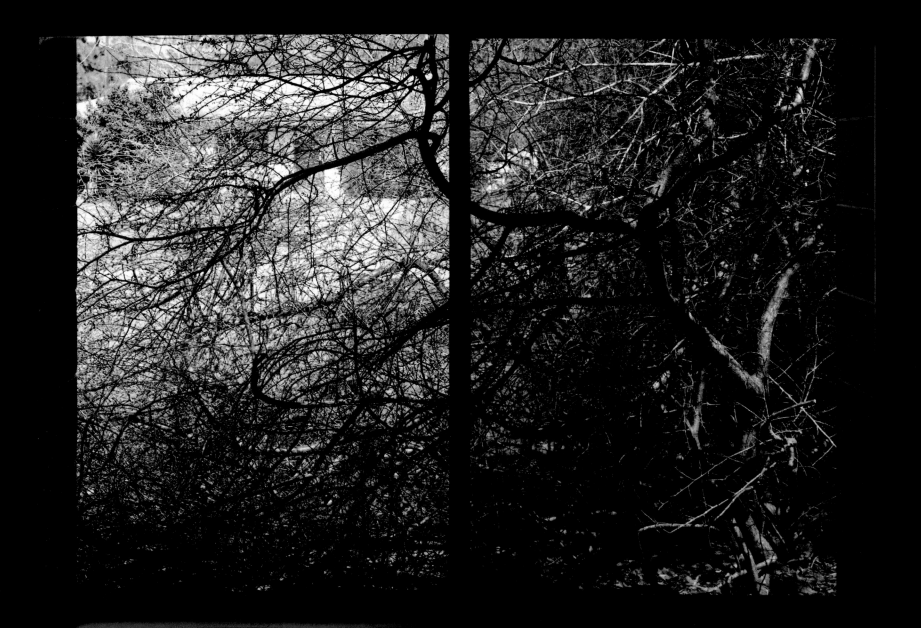

17 Inglewood, California

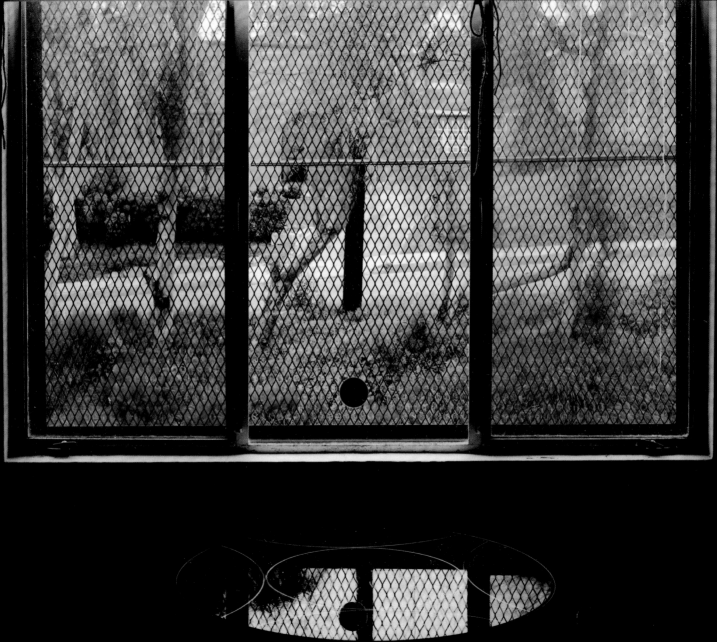

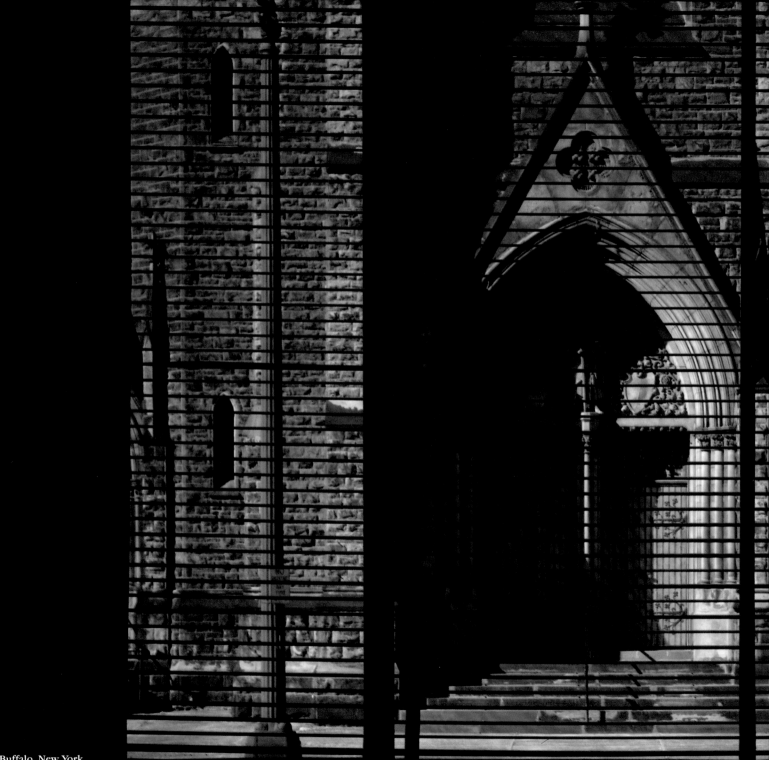

Buffalo, New York

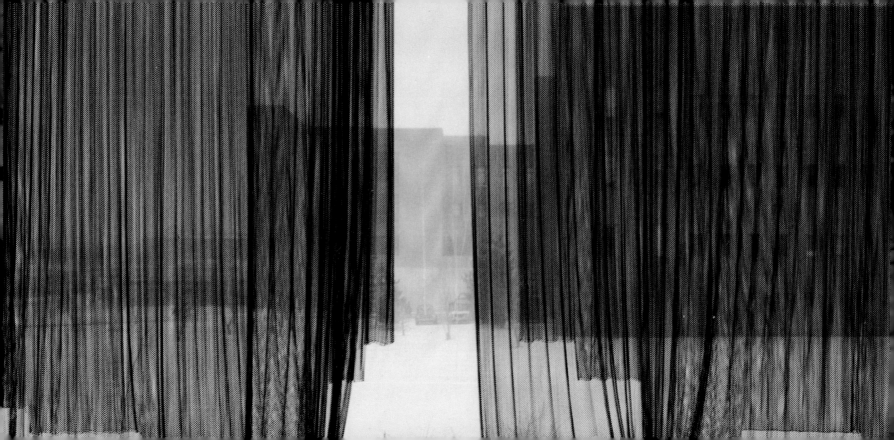

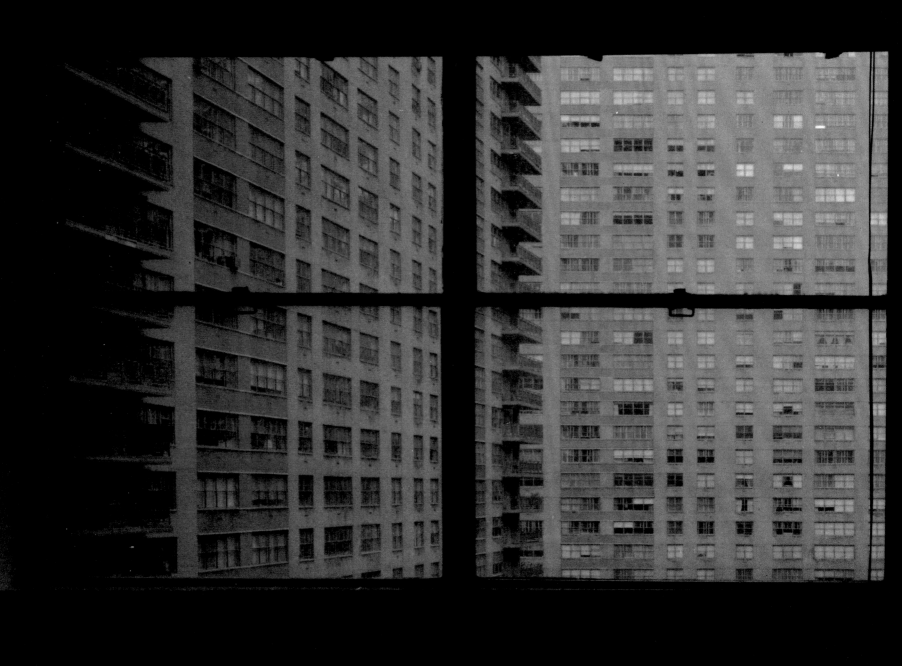

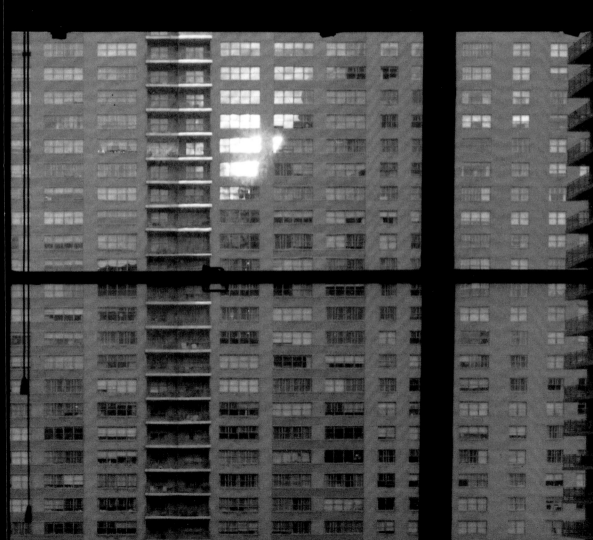

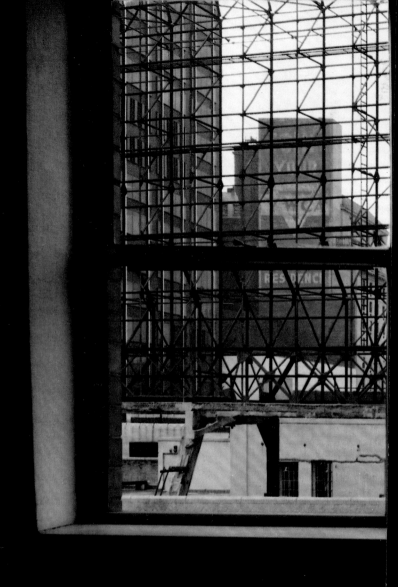

21 New York, New York

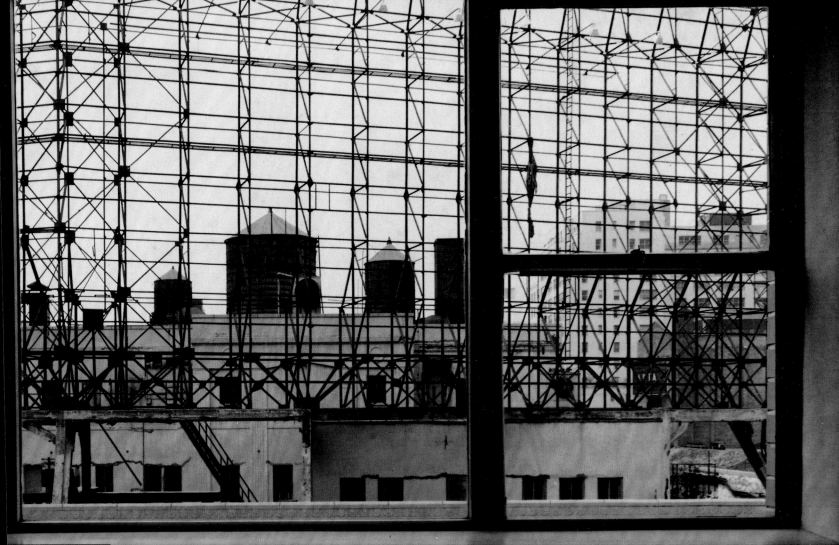

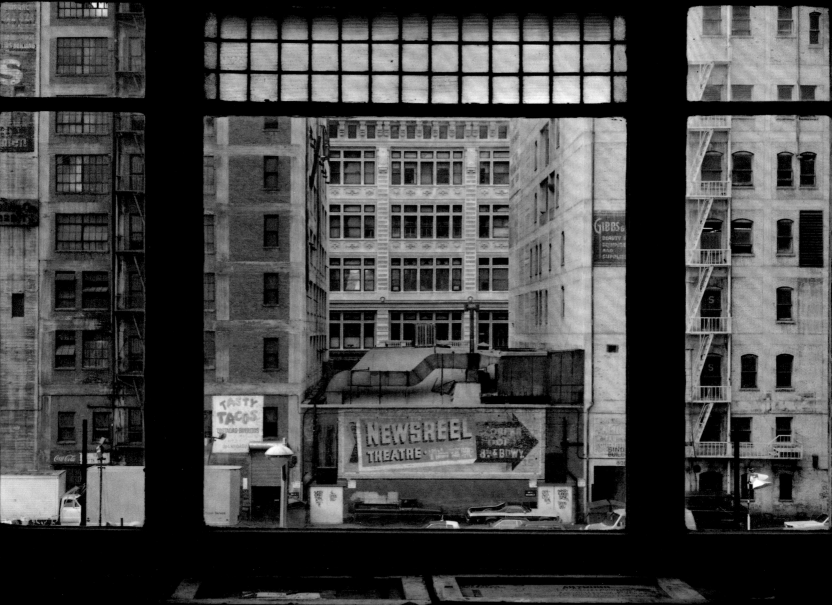

22 Los Angeles, California

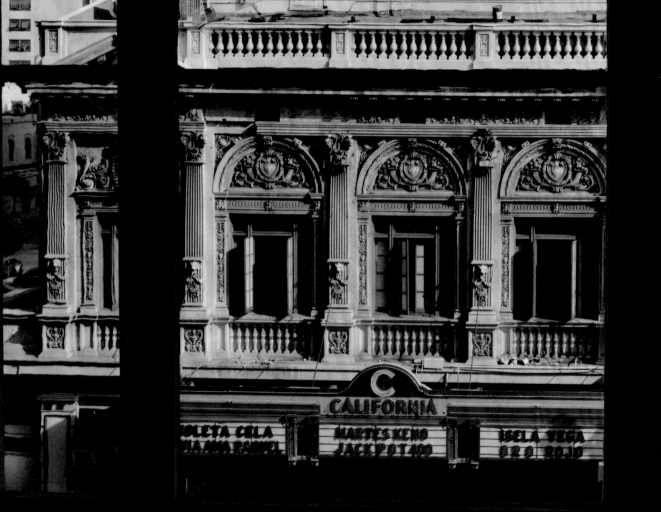

23 Los Angeles, California

24 New York, New York

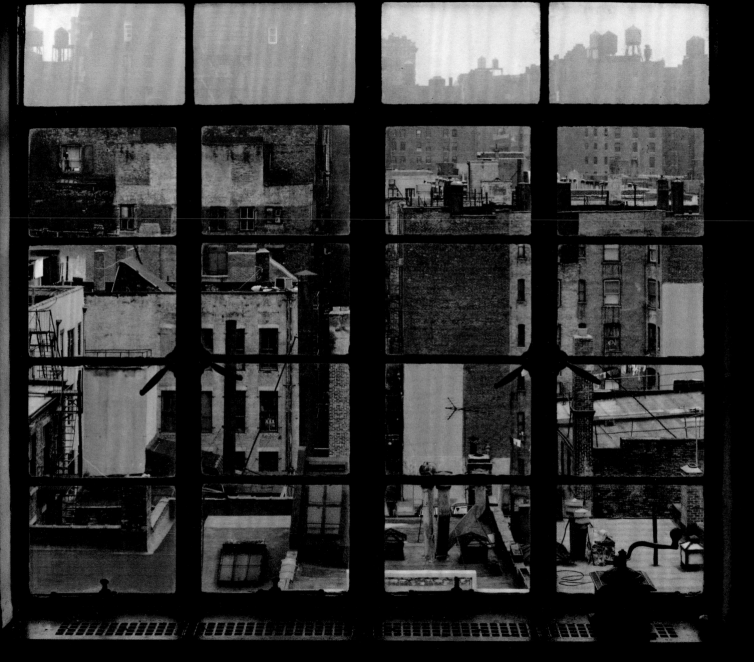

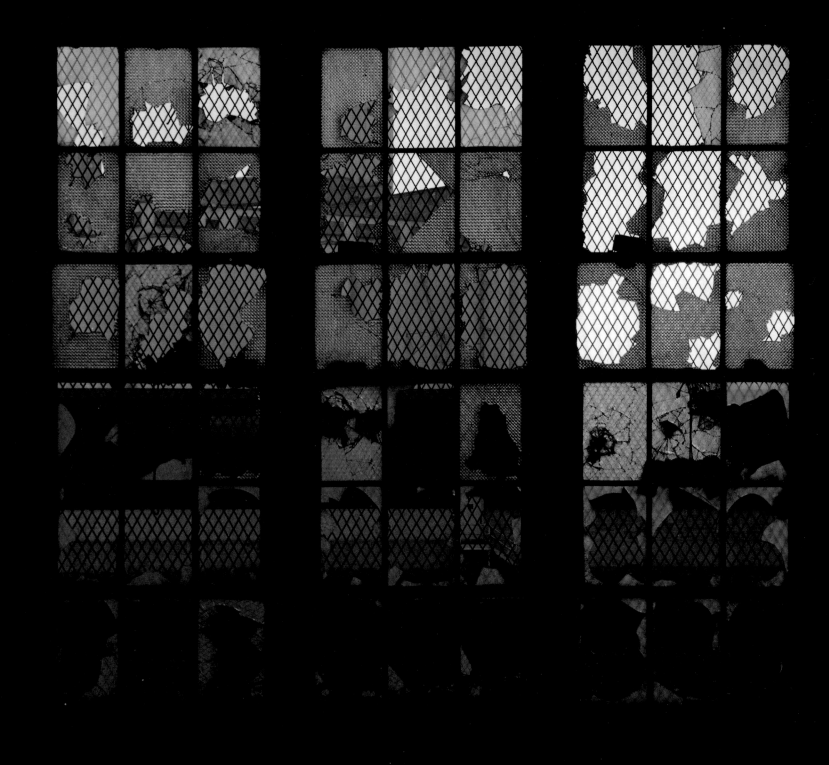

25 Buffalo, New York

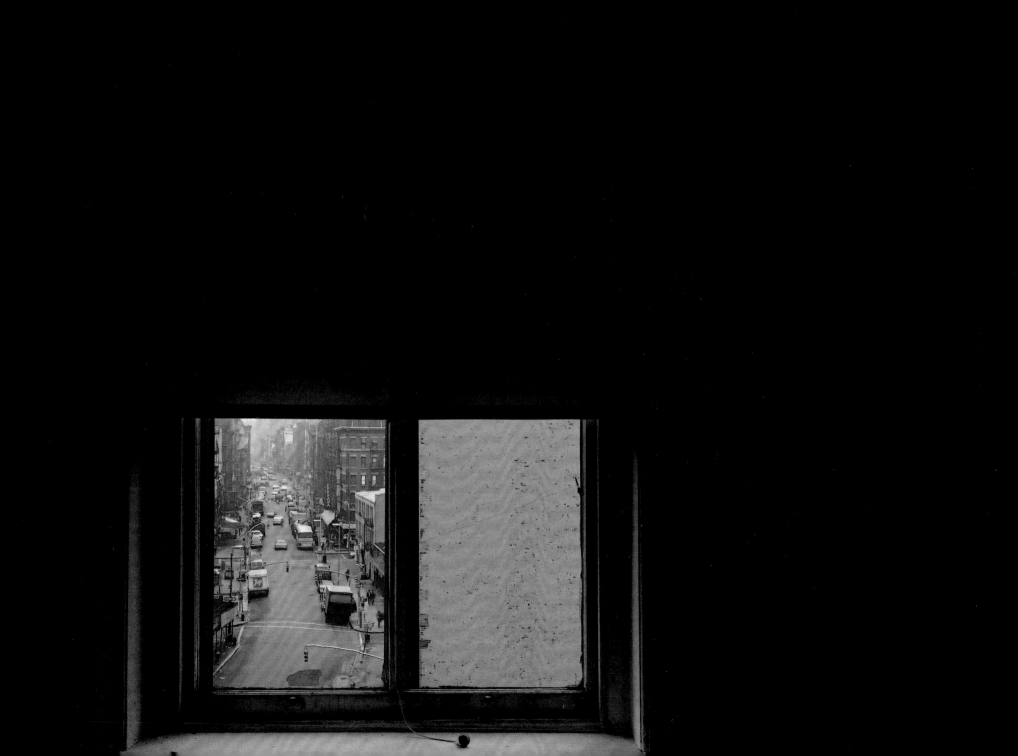

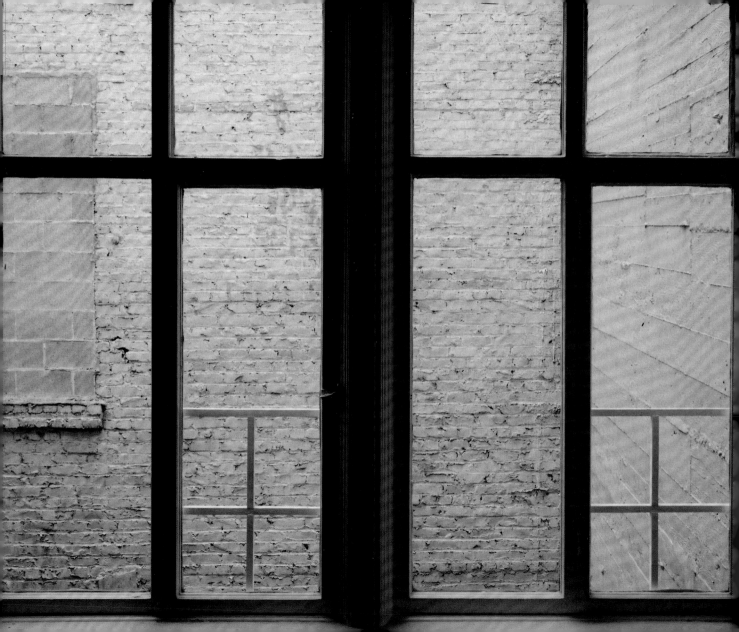

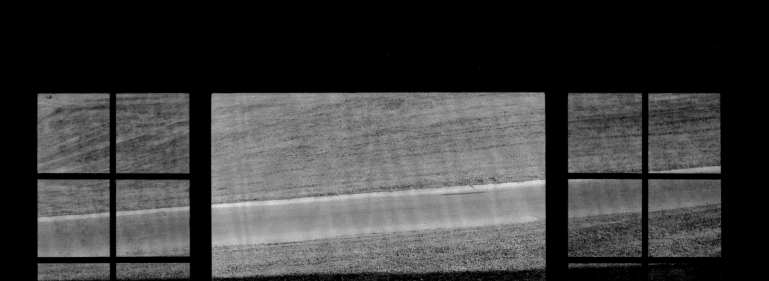

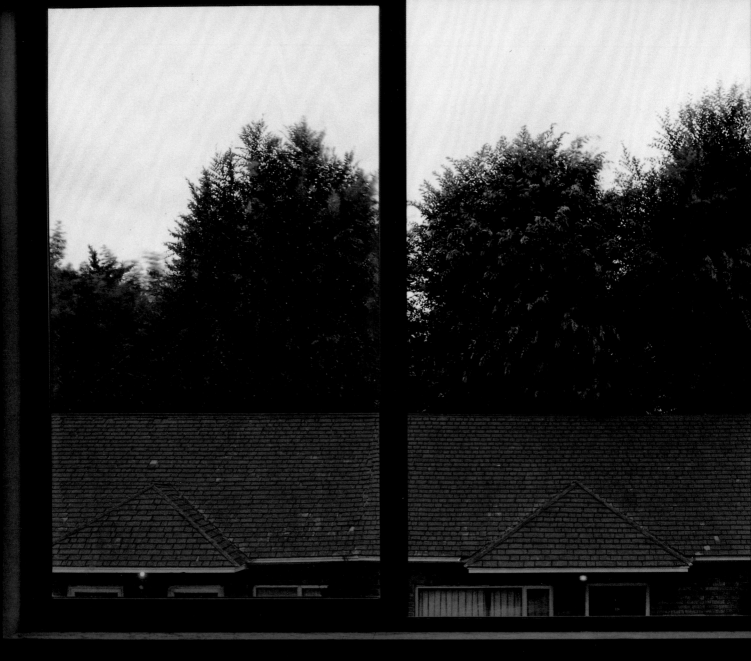

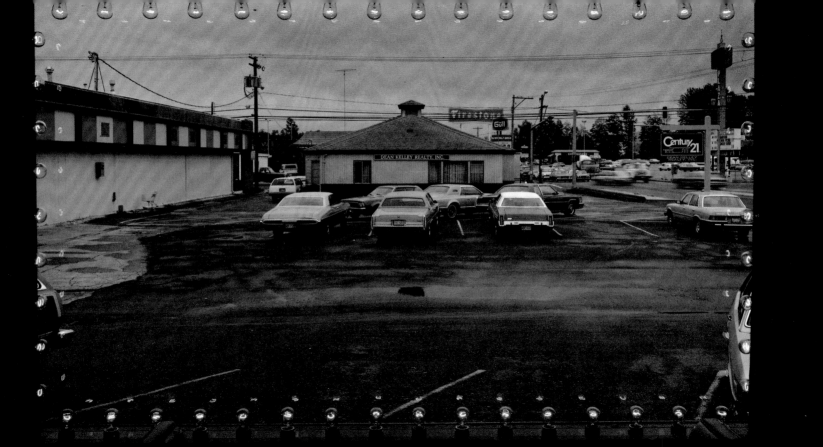

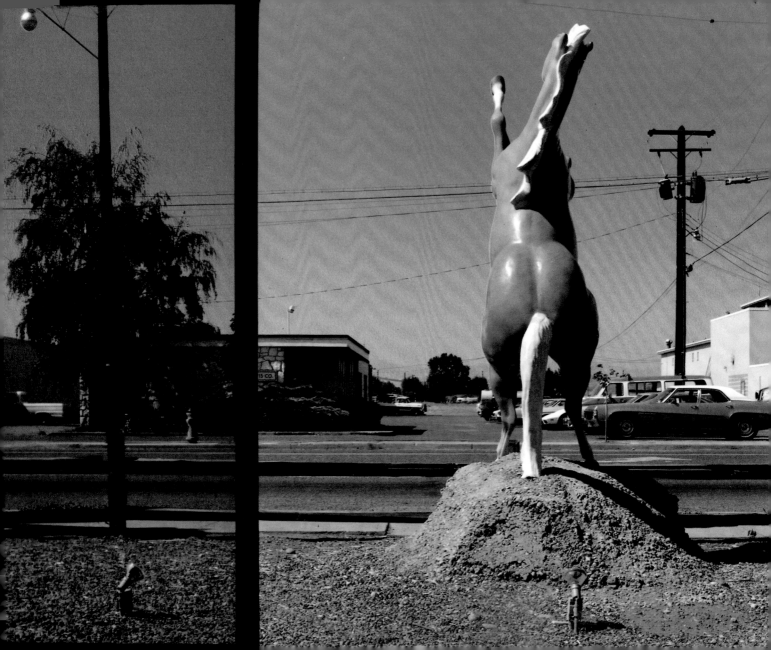

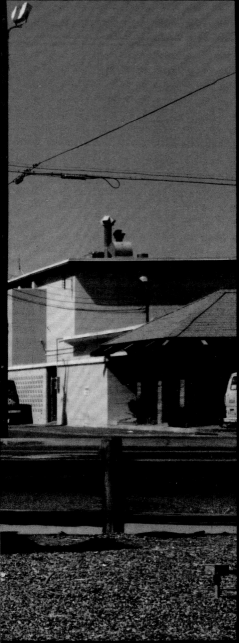

Mount Rushmore National Memorial, South Dakota

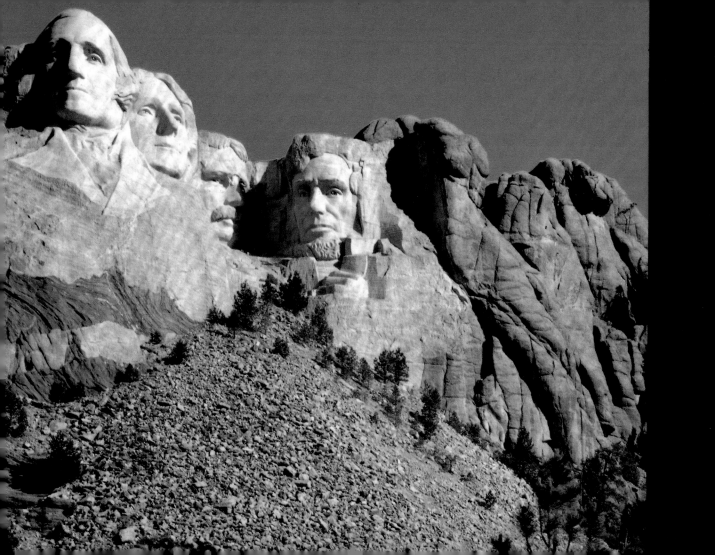

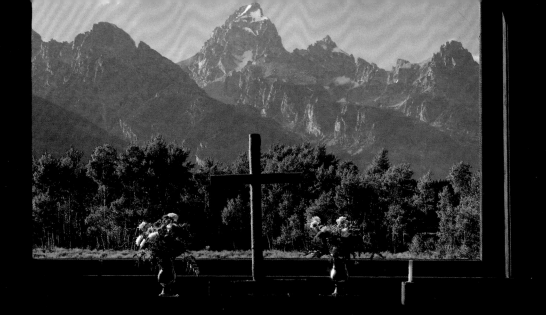

33 Moose, Wyoming

34 Butte, Montana

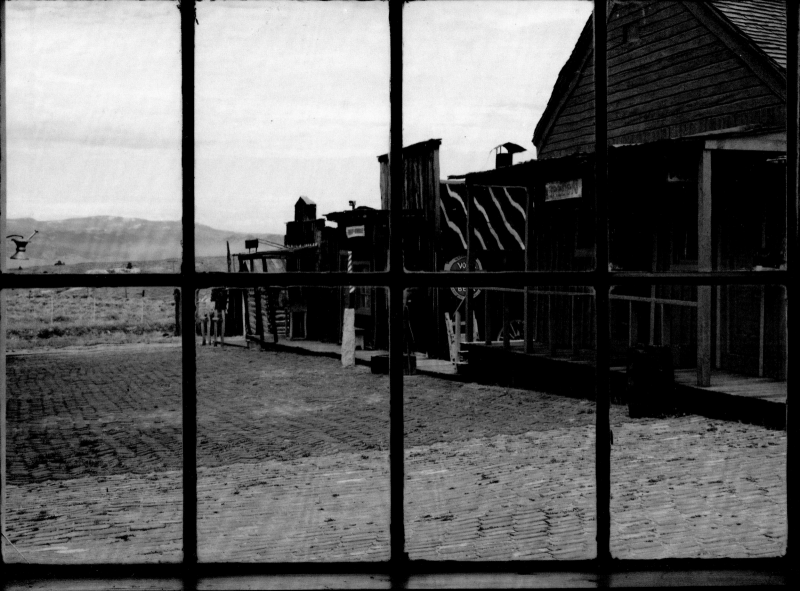

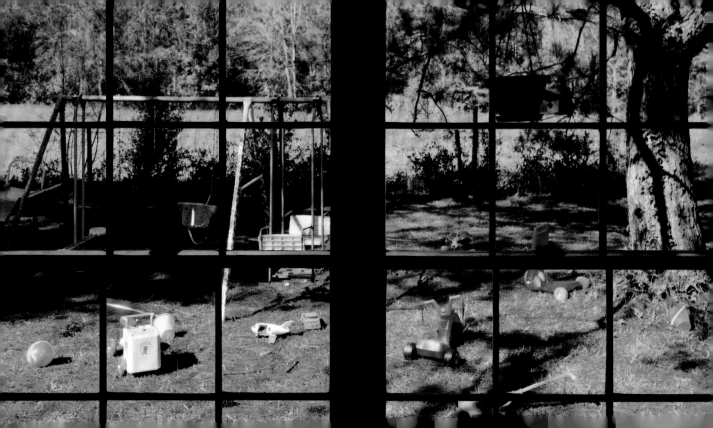

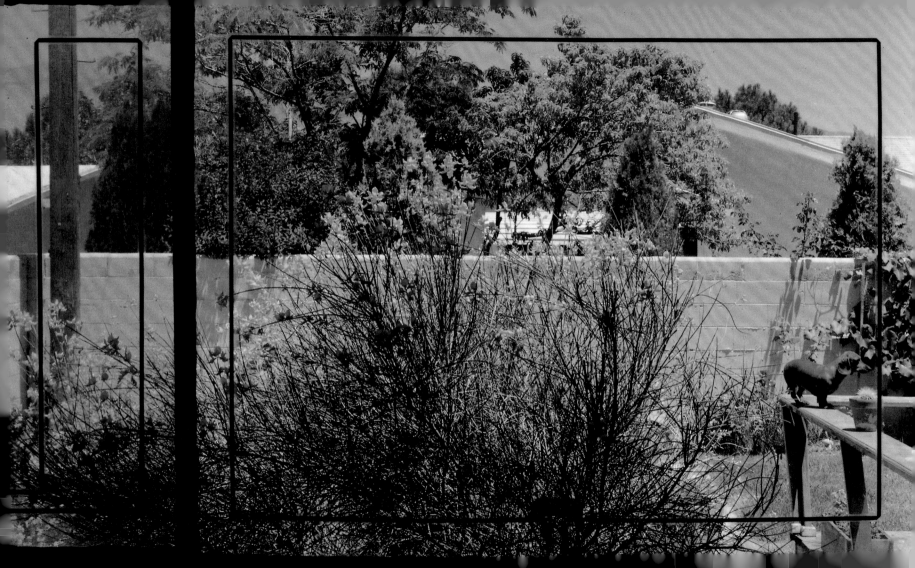

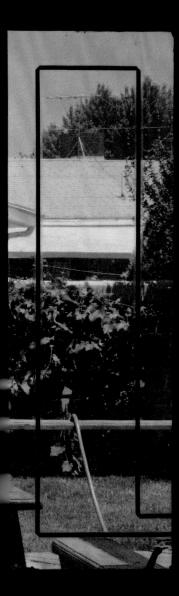

36 Albuquerque, New Mexico

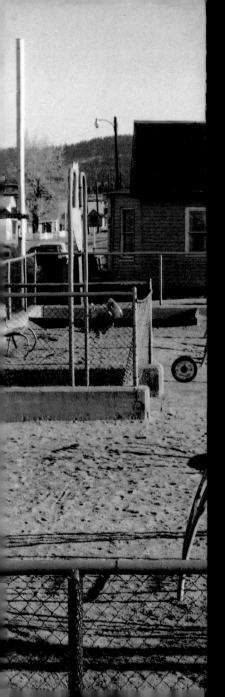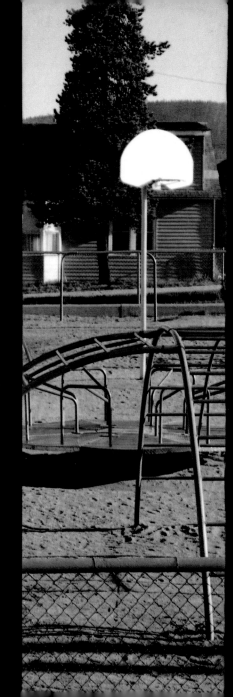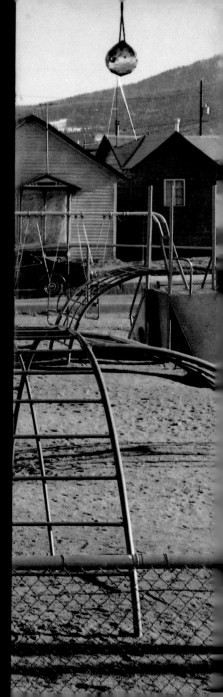

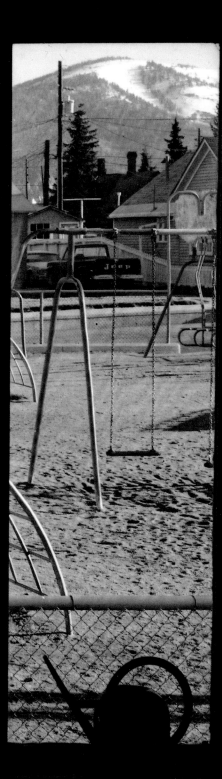

37 Leadville, Colorado

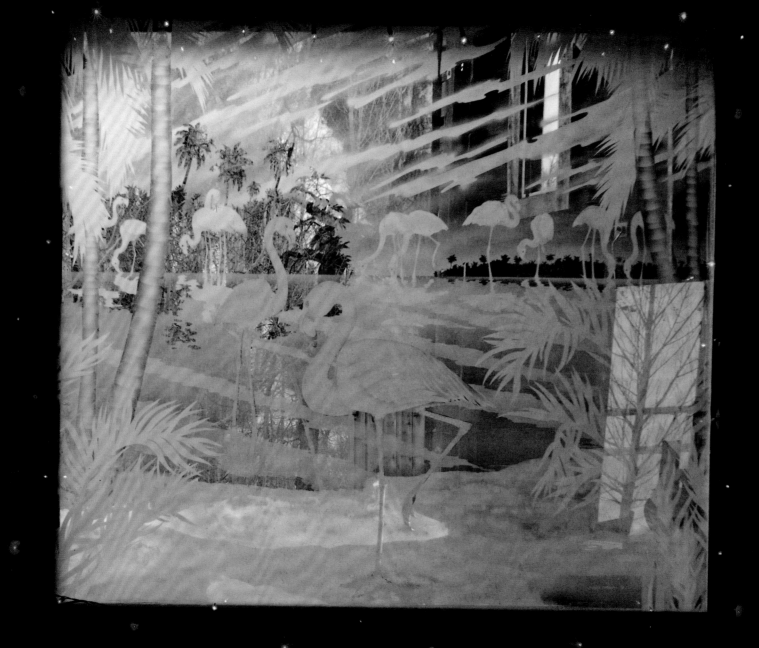

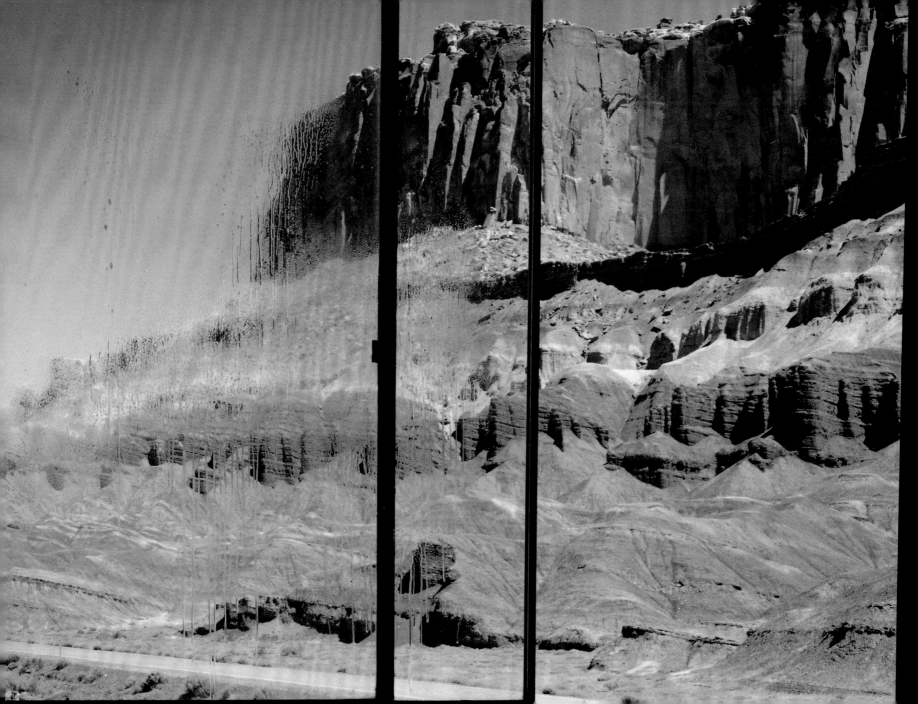

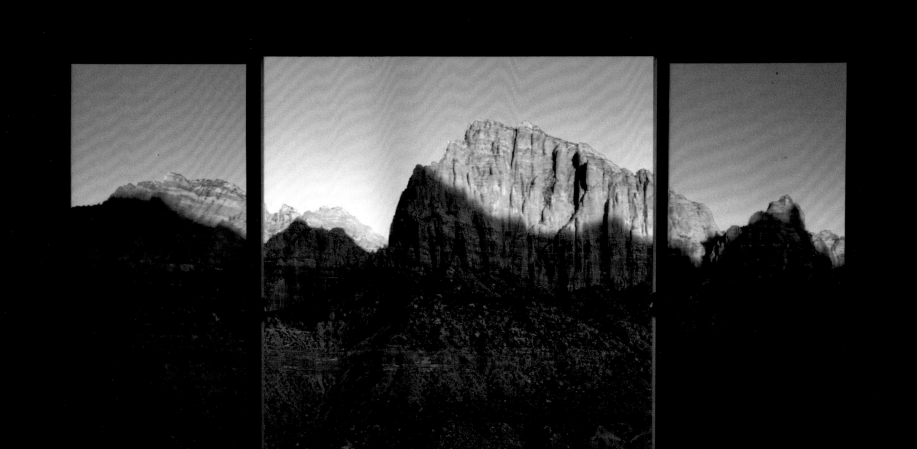

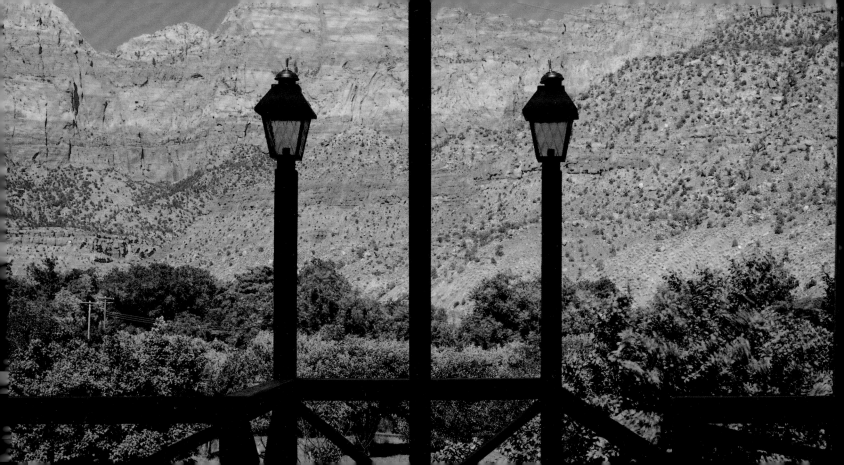

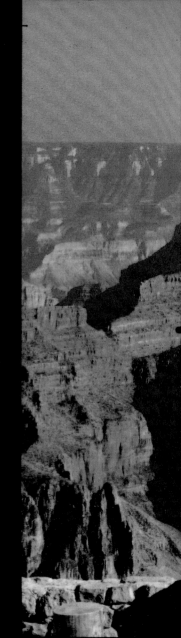
Grand Canyon National Park, Arizona

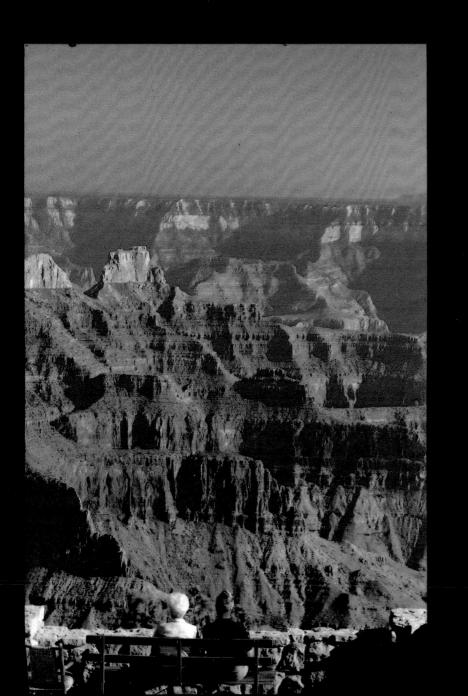
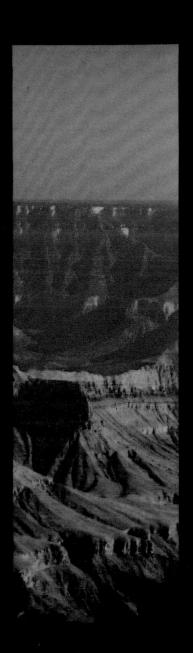

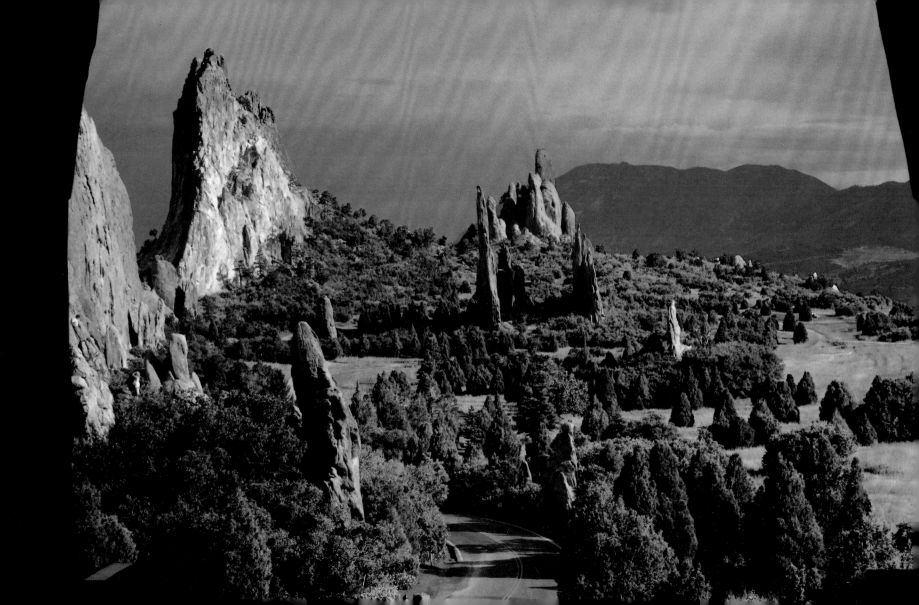

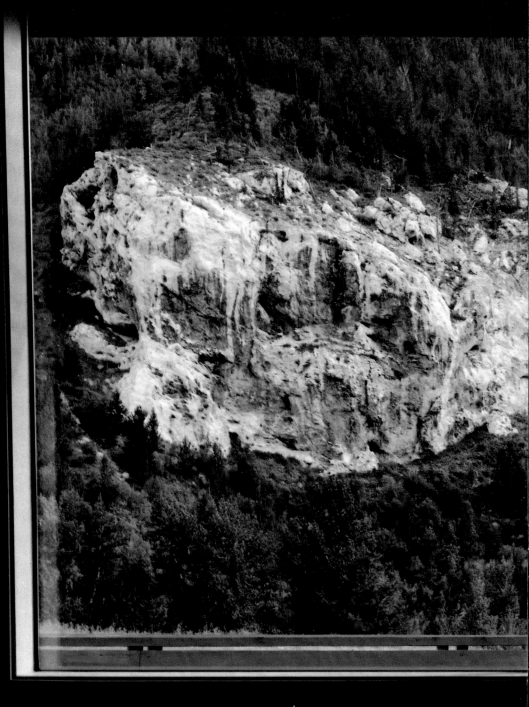

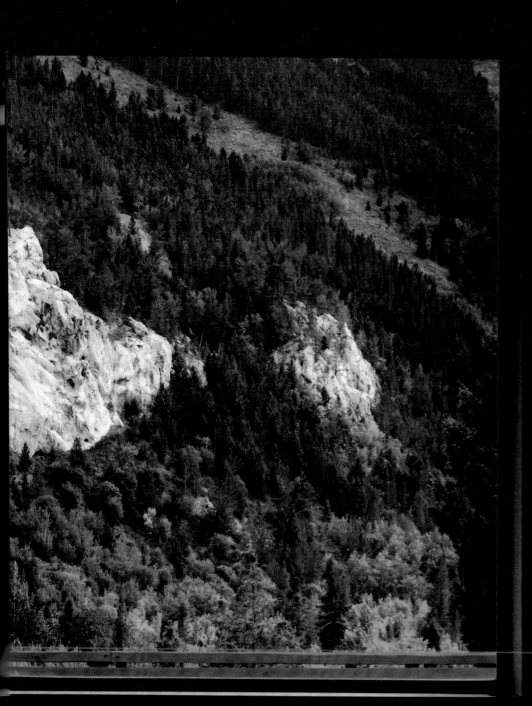

45 Anaconda, Montana

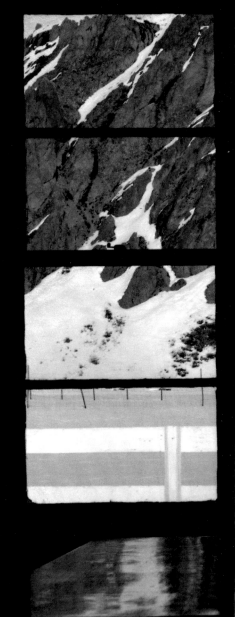

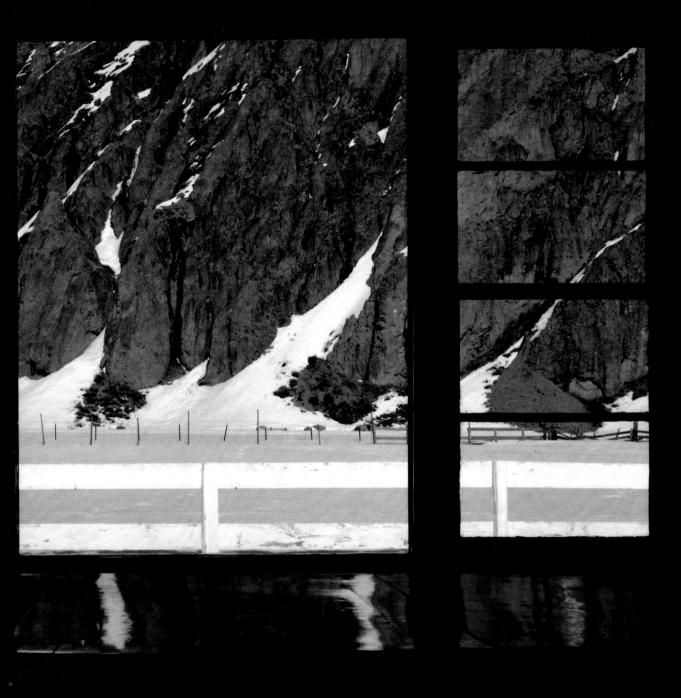

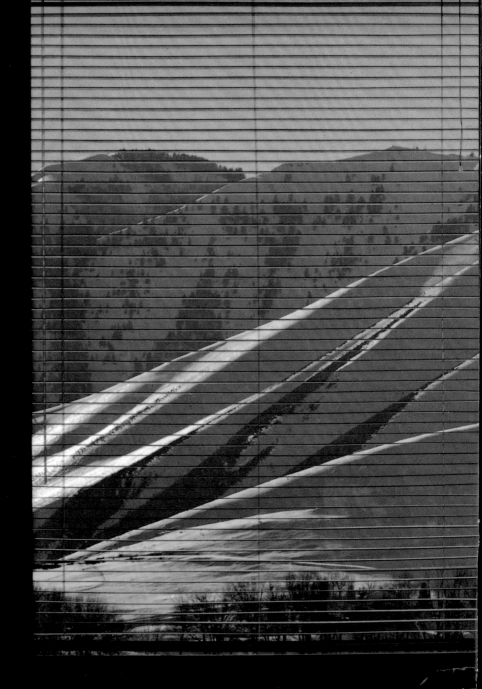

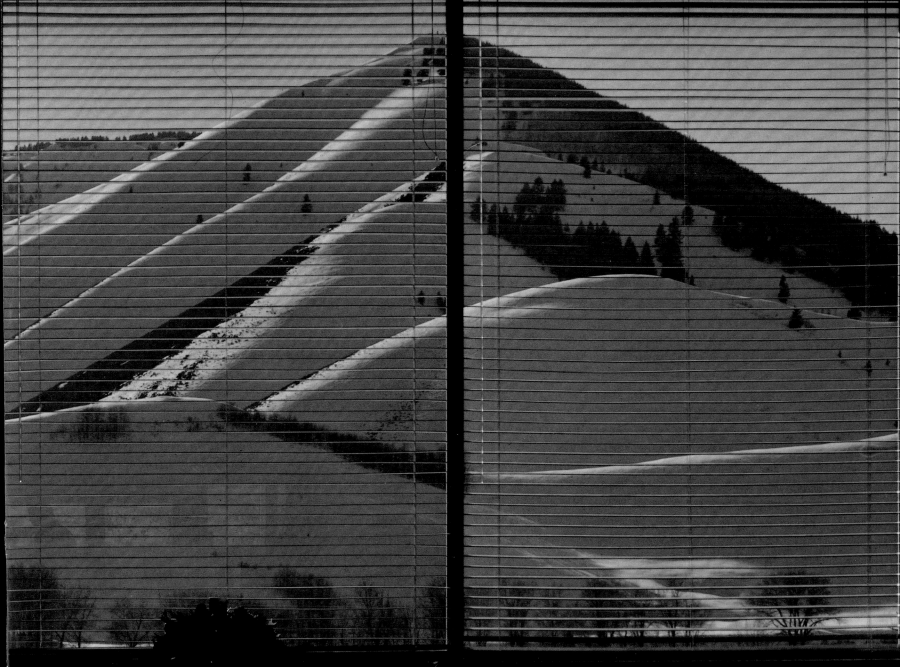

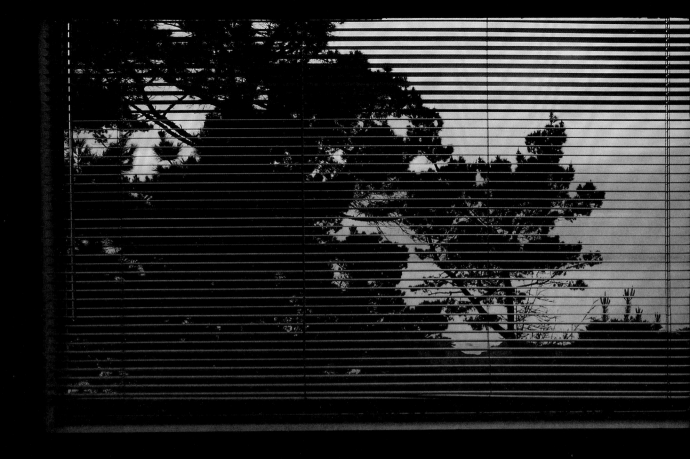

48 Carmel Highlands, California

49 Bayview, Washington

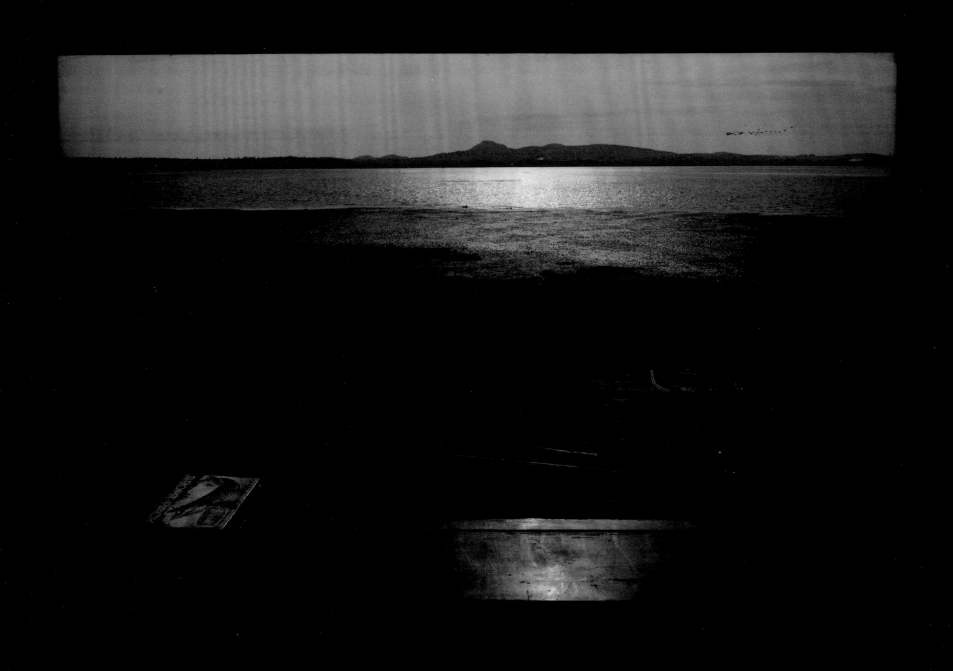

List of Plates

Edited by Terry Reece Hackford
Production coordinated by Amanda Freymann
Designed by Mike Fender
Composition by Composing Room of New England
Printed and bound by Balding + Mansell International Limited